Wisdom With Understanding is Better Than Rubies

Lurine Karon Greenberg Fine Arts Collection

REMBRANDT
ON PAPER

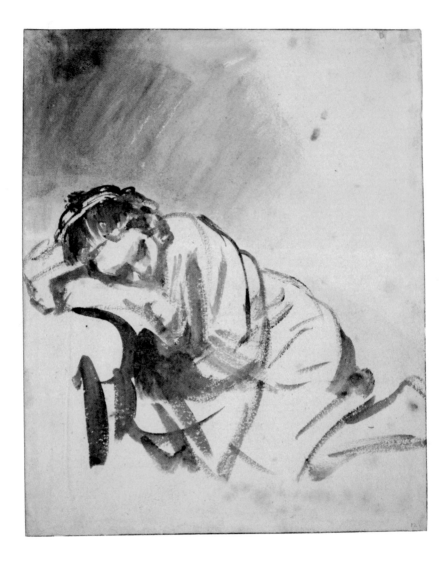

REMBRANDT ON PAPER

Hilary Williams

The J. Paul Getty Museum
Los Angeles

Dedicated, with love, to the memory of my mother, Rosemary,
who introduced me to the wonder of Rembrandt

With thanks to Martin Royalton-Kisch for reading the text,
and to my editor, Felicity Maunder

First published in the United Kingdom in 2009 by The British Museum Press
A division of The British Museum Company Ltd

First published in the United States of America in 2009 by
The J. Paul Getty Museum, Los Angeles

Getty Publications
1200 Getty Center Drive, Suite 500
Los Angeles, California 90049-1682
www.getty.edu

Gregory M. Britton, *Publisher*
Mark Greenberg, *Editor in Chief*

Library of Congress Control Number 2008943899
ISBN 978-0-89236-973-7

Frontispiece: *A young woman sleeping (Hendrickje Stoffels)*
c. 1654. Brush and brown wash, 24.6 x 20.3 cm

Photographs of British Museum objects are by the British Museum Department of
Photography and Imaging
Designed and typeset in Centaur by Peter Ward
Printed in China by C&C Offset Printing Co., Ltd

CONTENTS

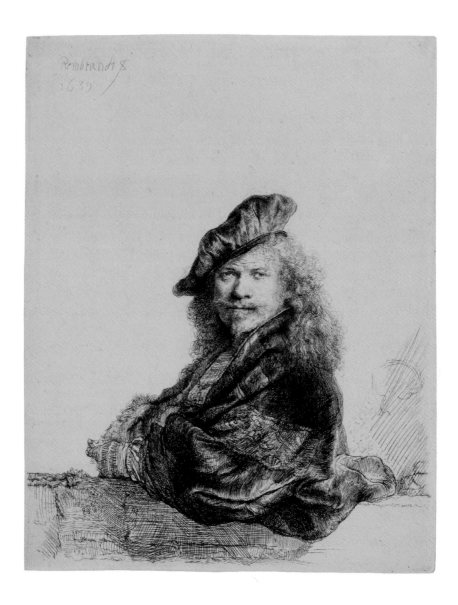

Rembrandt Harmenszoon van Rijn
(1606–69)

T HE DUTCH ARTIST Rembrandt van Rijn has always been considered one of the most brilliant talents in Western art. His work is seen as a benchmark of quality, in technique, composition and in the way in which the artist communicates his perceptiveness. He was prolific in painting, drawing and printmaking, and his works were prized during his lifetime and have continued to be much sought after ever since.

Rembrandt was at the forefront of what became known as the Golden Age of Dutch art. Although he is most often associated with the city of Amsterdam, he was born and raised in the old university city of Leiden, about thirty miles south-west of Amsterdam. He might have been expected to follow into his father's milling business, but he evidently showed great artistic potential from early on. After leaving the Latin School in Leiden, Rembrandt undertook a three-year apprenticeship with the Leiden painter Jacob van Swanenburgh before progressing to become a pupil of the fashionable Pieter Lastman in Amsterdam for about six months in 1624–5. Between 1625 and 1631 he returned to Leiden and established himself there as an independent master, but it seems that the lure of patronage in the bustling, cosmopolitan commercial city was too strong, and in 1631 he returned to Amsterdam, where he stayed for the rest of his life.

When the young and precocious Rembrandt arrived in Amsterdam, it was the place to be. Known by many as the 'Golden Swamp', it was a silty, damp, marshy land, much of which was bound together by wooden piles on

Self-portrait leaning on a stone sill
1639. Etching, touched in black chalk, 20.5 x 16.4 cm

which buildings were constructed, drainage being afforded by a network of concentric canals. The world came to Amsterdam to trade goods from the Orient, south-east Asia, India, the Baltic and most of Europe, and it was vital for successful merchants to have a base in the city. It was the greatest among the many fine and distinctive cities of the seven states which comprised the United Provinces of the Northern Netherlands, and in effect became its commercial capital, while the seat of government was based in the elegant official capital of The Hague.

The United Provinces – held together and governed by the Protestant figurehead, the Prince of Orange – vied for political and commercial power with the Southern Netherlands, which were governed by the Catholic regents of Spanish Habsburg power. The seat of Habsburg government was at Brussels, but politically and economically Antwerp became the vibrant commercial centre and port of the Southern Netherlands. As Amsterdam's star rose, it vied with Antwerp for commercial supremacy, and the two cities were in serious economic competition. This was reflected in an intense cultural rivalry, and in the 1630s Rembrandt must have felt compelled to compete with Peter Paul Rubens, who by the seventeenth century had consolidated Antwerp's reputation as an artistic centre.

Amsterdam's confidence was heightened after the city fathers secured a peace treaty with the previously threatening Spain in 1648, and a statement of intent to become a major commercial force appeared in the ambitious plans to construct a new Town Hall (now the Royal Palace) in stone and Italian Carrara marble, as the Eighth Wonder of the World. Nowhere is the mobility of Amsterdam society at the time more clearly demonstrated than in Rembrandt's most celebrated painting, *The Military Company of Captain Frans Banning Cocq*, known as *The Night Watch* (opposite). It was painted in 1642, which was simultaneously the worst and best year of the artist's life: his wife, Saskia, died, leaving him with an infant son, Titus, and yet he produced this spectacular, swashbuckling painting, one of the greatest in Western art. It is a portrait of a military group which banded together to protect its part

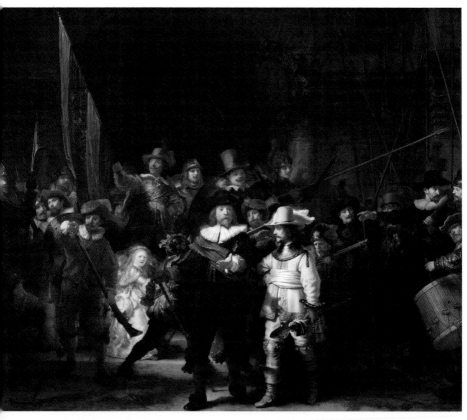

The Military Company of Captain Frans Banning Cocq, or *The Night Watch*
1642. Oil on canvas, 36.3 x 43.7 cm. Rijksmuseum, Amsterdam

of the city from Spanish incursions from the Southern Netherlands. The group's commanding officer, Captain Frans Banning Cocq, shown in a black costume with a red sash, was the son of an apothecary who had been reduced to begging on the streets for money. Despite this, Frans was able

to ascend the social hierarchy of Amsterdam. He trained as a lawyer and became an accomplished administrator in the City of Amsterdam, a member of its thirty-six-man council, an alderman, and then presiding burgomaster. In *The Night Watch* he is attended by his trusty lieutenant, Willem van Ruytenburgh, a wholesale merchant, wearing a cream uniform. The men are shown leaving their headquarters, the Kloveniersdoelen, where this picture was destined to hang. Their comrades, including eighteen officers, are professional and mercantile men. With this work Rembrandt redefined the military group portrait, the so-called '*schutterstuk*', which previously had presented horizontal registers of figures in straight lines across the canvas or panel. The composition is opened up by the strong diagonals created by the fall of light and the consequent casting of shadow, giving the scene drama, action and energy.

The increasing amount of disposable income and mercantile wealth in Amsterdam created an environment ripe to foster artistic patronage, and the city was a honeypot for patrons and collectors. In the seventeenth century the Dutch showed a particular penchant for buying and commissioning art, especially painting. Growing numbers of artists were training in all the cities and, as each painter needed to find a niche market, most specialized in a specific type, such as landscape, townscape, still life, genre, interiors, portraiture, biblical, historical or other subjects. Rembrandt was exceptional in this respect because he produced almost every type of subject. He was also perfectly positioned to attract the patronage of the newly confident Amsterdam society. Social and familial networks connected him to many of the most influential people of the time, including religious figures, civic leaders and officials, medical men and lawyers, and many such individuals feature in his portraiture.

An artist in his studio
c. 1632–3. Pen and brown ink, 20.5 x 17 cm
J. Paul Getty Museum, Los Angeles

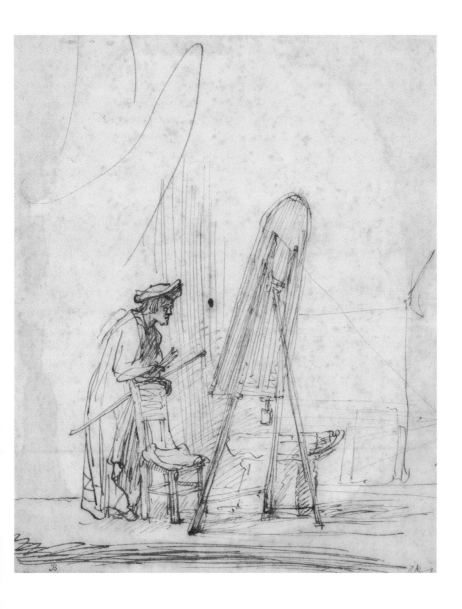

Once established as an artist, Rembrandt sought to augment his income and from the 1630s he began to accept pupils. Financially this was very beneficial: at the height of his fame, he had sixty pupils enrolled, with each paying him a fee of 100 florins (guilders) per annum. This was a generous income and it is easy to understand how he thought he would be able to afford the mortgage on a large house on Amsterdam's Jodenbreestraat (now the Rembrandthuis Museum). His pupils were already artists before enrolling with him so he did not train them from scratch. Rather they went to him to learn how to create the fashionable 'Rembrandt look'. As the leading artist in Amsterdam at the time, his reputation soon spread, both nationally and internationally, and we know that the English diarist John Evelyn was determined to visit Rembrandt's studio when he visited the Netherlands in 1641.

The studio in which the pupils would work was originally in the artist's house. His sixty or so pupils would not all be present at once, but would attend sessions in groups to draw from the model with the master (see the etching on p. 15). Rembrandt's house combined the functions of studio space, living rooms for the family, a place for his etching press, rooms for entertaining clients and a store for his collection. The packed conditions there were a far cry from the elegant, spacious, light-drenched atelier and house of Rubens in Antwerp, with which Rembrandt must have been tempted to compete. Thus Rembrandt, bombarded with students between the late 1630s and early 1640s, needed extra accommodation for them, and so he hired a warehouse on the Bloemgracht in which to teach. It sounds amazingly makeshift. The painter and writer Arnold Houbraken tells us that 'each of his pupils had a space for himself, separated by paper or canvas, so that they could paint from life without bothering each other'. This reveals a lot about the importance attached to life drawing as a means of training artists: it followed in the spirit of Renaissance artistic education in which it was considered of central importance to have an understanding of how to represent the human figure.

Two subjects offer a window on to the world of Rembrandt's teaching studio. In *Male nude, seated and standing ('The walking frame')* (p. 16), we see that the models would apparently pose while everyday family life went on around them: here, a child is being encouraged to walk supported by a wheeled walking frame. In both the drawing and the related etching of *The artist drawing from the model* (pp. 14 and 15) we see Rembrandt himself, with turbaned head, sketching from the nude female model in front of him. The studio is shown as a fairly cramped space, filled with artist's props: costume, hats, feathers, statues and an easel.

Despite his social and professional connections, income from teaching, and status as the leading artist in Amsterdam, Rembrandt experienced financial difficulties and in 1656 was declared bankrupt at the Insolvency Court in the Town Hall. It is often thought that Rembrandt became insolvent due to three key factors: first, his works went out of fashion; secondly, he had overstretched himself financially in taking out a mortgage on his splendid house, on the expectation that his career would continue in the ascent; and thirdly, he collected great works of art, which cost more than his income to acquire.

Like many artists, Rembrandt had acquired works of art as a reservoir of images which could inspire his own compositions. His collection was wide in its inclusion of Renaissance and contemporary oils, prints and drawings, but was not as grandiose as that of Rubens who, at the time of his death, held twelve paintings by Titian, a princely collection of works by the Venetian painter who also inspired Rembrandt. Ironically, the inventory of Rembrandt's possessions in 1656, drawn up on his bankruptcy, affords us a marvellous insight into the objects that he owned and used in his large house. Listed among the works of art he possessed are 'the precious little book of Andrea Mantegna'; a work by Michelangelo; others by Raphael, Bassano and Giorgione; numerous prints by or after Tempesta, the Carracci, Cranach, Dürer, Schongauer, Holbein and many others, including his contemporaries; and several Classical busts and medals.

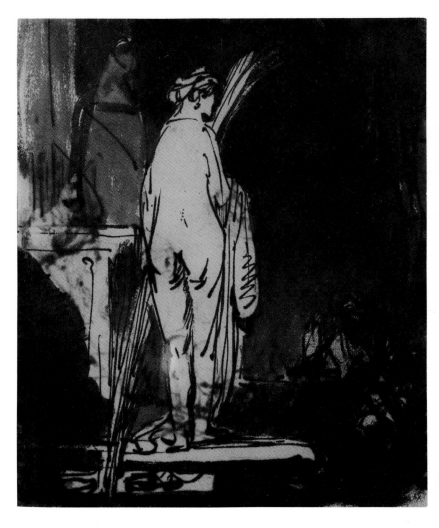

The artist drawing from the model
c. 1639. Pen and brown ink with brown wash, 18.8 x 16.4 cm

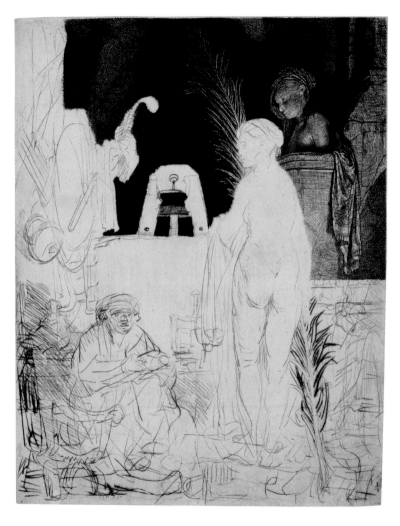

The artist drawing from the model
c. 1639. Etching, drypoint and burin, retouched with black chalk, 23.2 x 18.4 cm

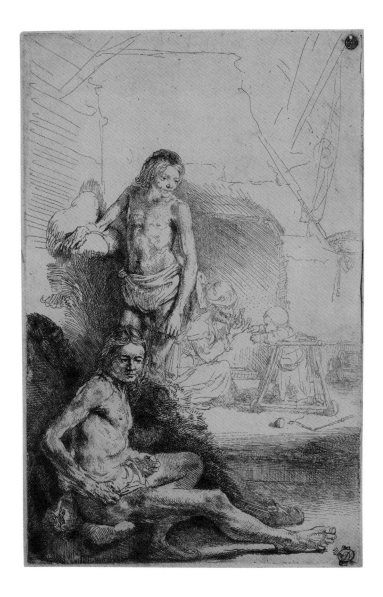

Because of the mass of mercantile money available to expend on luxury goods, Amsterdam became a great centre for auctions of prestigious and expensive art, especially Renaissance works. So even though Rembrandt, unlike many of his contemporaries, never travelled to Italy, at the auction houses of Amsterdam he encountered many great pieces of Italian Renaissance art. In 1639 Rembrandt saw at auction Titian's renowned oil painting *Portrait of a man with a quilted sleeve*, also known as *Ariosto*, of *c.* 1512 (National Gallery, London), and made a thumbnail sketch of it. He studied the work more closely when he later viewed it in the home of its purchaser, the Sicilian merchant Ruffio. The painting inspired Rembrandt in 1639 to sketch an experimental self-portrait, then a related etching, the *Self-portrait leaning on a stone sill* (see p. 6), leading in 1640 to an elegant self-portrait in oil, now in the National Gallery, London.

Other works seen by Rembrandt include Raphael's famous portrait of the courtier Baldassare Castiglione (Musée du Louvre, Paris), which he recorded in a small, rapid sketch (Albertina, Vienna), and Andrea Mantegna's drawing *The Calumny of Apelles*, which he also carefully copied: both the Mantegna and the Rembrandt are now in the British Museum (p. 18, top and bottom). The famous medal made by Pisanello around 1440, showing the Mantuan ruler Gian Francesco Gonzaga, was also known to Rembrandt as he included the form of Gonzaga on horseback as the figure of the centurion in the later states of his etching *The three crosses* of 1653 (p. 67).

The British Museum holds over eighty drawings attributed to Rembrandt, along with the richest collection of his prints in the world. This book presents a selection of these works, spanning the artist's many types of subject. In the portraits we meet some of the influential characters

Male nude, seated and standing ('The walking frame')
c. 1646. Etching, 19.4 x 12.8 cm

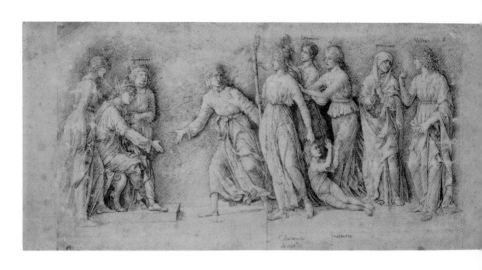

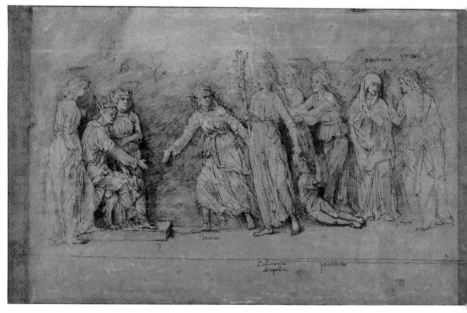

of seventeenth-century Amsterdam, along with members of Rembrandt's own family. In the biblical subjects we see the skill with which Rembrandt communicates the pathos of the human predicament, and in the landscapes his ability to capture mood and atmosphere. Nothing escapes the artist's incredibly perceptive eye.

(top) *The Calumny of Apelles*, by Andrea Mantegna
c. 1504–6. Pen and brown ink with brown wash, 20.6 x 37.9 cm

(bottom) *The Calumny of Apelles* (by Rembrandt, after Mantegna)
c. 1652–4. Pen and brown ink with wash, 26.3 x 43.2 cm

PORTRAITURE

REMBRANDT produced numerous self-portraits throughout his career, including over sixty in oil and many drawings and etchings. The *Self-portrait with mouth open* of *c.* 1628–9, with its bold shaft of light descending from the top left, glancing across his face and bulbous nose, is the earliest drawing by the artist in the British Museum. It is striking for its immediacy and Rembrandt looks as though he is in conversation with us.

In this drawing the crisp-edged lines of Rembrandt's curls and collar are drawn carefully with a pen in brown ink while the broad areas of tone in his hair and clothing are drawn with a soft sable brush in grey ink wash.

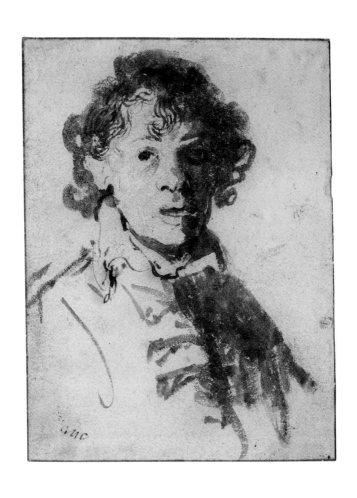

Self-portrait with mouth open
c. 1628–9. Pen and brown ink with grey wash, 12.7 x 9.5 cm

Rembrandt's experimentation with dramatic effects can be seen clearly in the small self-portrait etching of 1630, barely the size of a playing card, in which he strikes a grimace of lively surprise. It is one of the most dramatic and theatrical of his self-portraits, and strongly lit in a way that would later be described as Baroque. When it was made it would have been considered trendy and experimental. But who was the intended viewer? It is likely to have been for Rembrandt's own consumption; he is experimenting with and learning from his own portrait, rather than taking risks with representations of important patrons.

The artist's image and perception of himself soon becomes more swash-buckling and indicative of his aspirations, as in the *Self-portrait in a soft hat*, dated 1631. This is a strange hybrid work. Known as a 'touched etching', it is both a print and a drawing: the face, hair and hat are printed while the rest of the body, the collar and the arch are drawn, mostly in chalk. The inscription, which gives the artist's age as 'AET.24', shows that Rembrandt made this image before his twenty-fifth birthday on 15 July 1631.

Self-portrait with beret, wide-eyed
1630. Etching, 5.1 x 4.6 cm

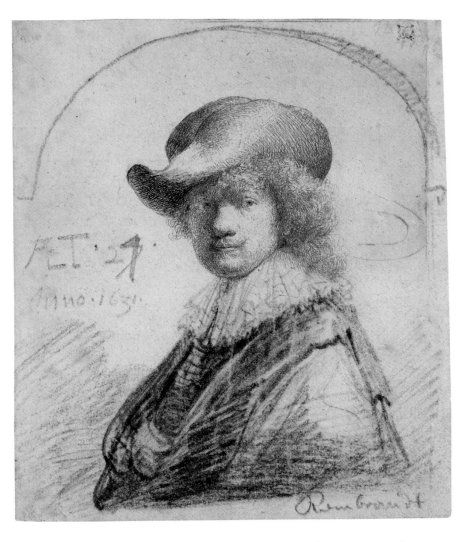

Self-portrait in a soft hat
1631. Etching, touched in black chalk, 14.8 x 13 cm

REMBRANDT'S MOTHER, Neeltgen Willemsdr. van Zuytbroeck, clearly exerted a strong supportive influence on the artist's life. She appears in many fastidiously observed early portraits in oils, prints and drawings, as herself or in the guise of biblical figures. Rarely has an artist portrayed the crinkly, paper-thin skin of old age so effectively. Neeltgen was part of the household when Rembrandt married Saskia van Uylenburgh in 1634 and when they set up home in the large smart house on the Jodenbreestraat in Amsterdam. She died in her seventies, in 1640, when Rembrandt was at the height of his fame; he received around 2,500 guilders from her estate.

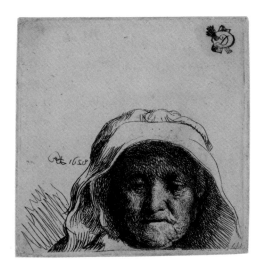

The artist's mother, head only, full face (second state)
1628. Etching, 6.3 x 6.4 cm

Rembrandt met his wife, Saskia van Uylenburgh, through a business associate, the art dealer Hendrik van Uylenburgh, who was Saskia's cousin. Her late father, Rombertus, a lawyer, had been burgomaster of Leeuwarden in the northerly province of Friesland and a significant public figure. Saskia was one of his eight heirs and received a handsome inheritance on his death. Rembrandt and Saskia were betrothed in June 1633; to mark the occasion Rembrandt made a sensitive portrait of his beloved (now in Berlin) in the special medium of silverpoint, and inscribed and dated it.

The couple's first child, Rombertus, and two subsequent children died in infancy, but their fourth child, Titus, survived into adulthood. Many drawings show Rembrandt's phenomenal skill in perceiving and communicating the magical moments of childhood, recorded in his immediate environment. *Two women teaching a child to walk* of c. 1635–7 (p. 26, top), drawn in the distinctive Netherlandish red chalk, shows Rembrandt's keen eye for the positioning of his subjects. The two women are very protective of their precious charge: the toddling child wears a kind of seventeenth-century crash helmet, comprising a roll of padded linen or leather linked by straps over the head and secured by earflaps and a ribbon under the chin. It is interesting to compare this snapshot of early family life with the drawing *A child being taught to walk*, of c. 1656, two decades later, which portrays different family members (p. 26, bottom). Here Rembrandt draws with a positive touch in reed pen and brown ink.

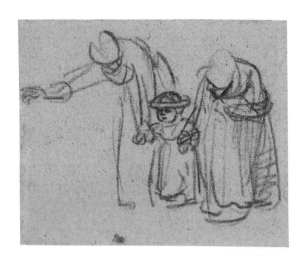

Two women teaching a child to walk
c. 1635–7. Red chalk, 10.3 x 12.8 cm

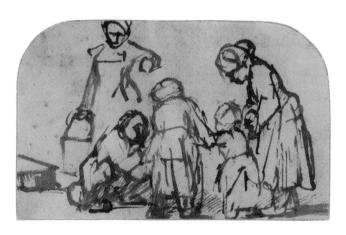

A child being taught to walk
c. 1656. Pen and brown ink, 9.3 x 15.4 cm

REMBRANDT made poignant drawings of Saskia while she was apparently weakened by her continual pregnancies, often representing her in bed, propped up on voluminous pillows. *A woman lying awake in bed* of *c.* 1635–40, drawn with a reed pen and brown ink, probably depicts Saskia, resting her head on her hand in a rather melancholic gesture, fed up with illness. Saskia died on 14 June 1642, under the age of thirty, after just eight years of marriage. She left an infant son, Titus, then only nine months old. Her will stipulated that Titus was heir to her fortune but that her husband could make use of the income from it for as long as he lived, if he remained unmarried.

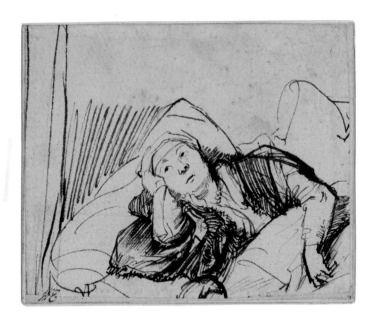

A woman lying awake in bed
c. 1635–40. Pen and brown ink, 8.4 x 10.4 cm

After Saskia's death, the most pressing problem for Rembrandt was to look after the infant Titus. As a result, Geertje Dircx, a young widow from the province of North Holland, was brought into the household as a nurse. It has often been suggested that this drawing, probably dating from *c.* 1638, represents Geertje in North Hollander costume. Another drawing, in the Teylers Museum, Haarlem, shows the same figure from the back. An inscription on the back of the Haarlem drawing reads '*De mine moer van Titus*' ('the wet nurse of Titus'). Theoretically Geertje might have been hired in 1642, while Titus was still an infant, but may have been known to Rembrandt prior to this.

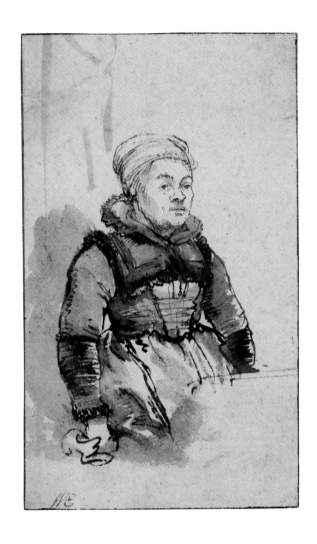

A woman in Dutch national costume
c. 1638. Pen and brown ink, 13 x 7.8 cm

HENDRICKJE STOFFELS (born *c.* 1626), the daughter of a soldier from near Arnhem, had entered Rembrandt's life by October 1649. She lived as Rembrandt's common-law wife and they never married, probably owing to the terms of Saskia's will whereby Rembrandt would have forfeited his income from her fortune if he had remarried. In 1654 Hendrickje was rebuked by the Council of the Reformed Church for living with Rembrandt out of wedlock. She bore their daughter, Cornelia, later that year.

Rembrandt drew Hendrickje regularly in the mid-1650s. *A young woman sleeping (Hendrickje Stoffels)* (see the frontispiece) is a tour de force of skill in draughtsmanship. Unusually for Rembrandt it is worked entirely with a brush and brown ink, giving an almost oriental touch to the brushwork and flow of wash. The figure has her feet up on a bed or couch, creating a quiet and restful atmosphere. Rembrandt has seen the structure of her form and represented it at first application to the paper. Areas that function as highlights are left clear, allowing the pristine quality of the paper to shine through, suggesting a highlight rather than applying one in a white medium. This is the sort of technique that one might expect from a printmaker who has to think ahead as to which areas need to be left blank to allow the paper to show through. The drawing is a masterpiece. In comparison, the drawing *A young woman seated in an armchair* (opposite) looks less immediate; the Renaissance-like style of the figure's costume perhaps indicates that it was a preliminary sketch intended as a study for a historical subject.

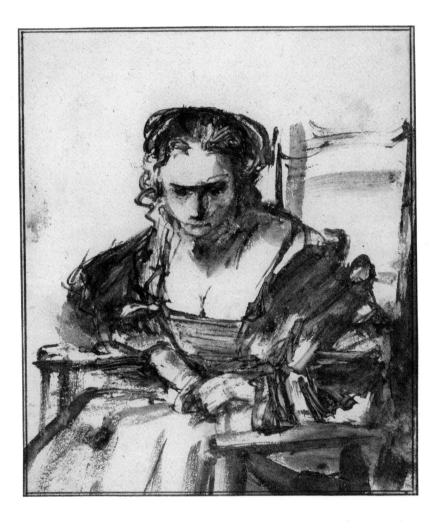

A young woman seated in an armchair
c. 1654–60. Reed pen and brown ink
with brown wash, 16.3 x 14.3 cm

THE PREACHER Jan Cornelisz. Sylvius was Saskia's cousin, and godfather or guardian to at least one of Rembrandt and Saskia's children. He was a minister in the Dutch Reformed Church and officiated at the baptisms of two of Rembrandt and Saskia's children, Rombertus and Cornelia, both of whom died in infancy. The British Museum holds both a rapid, clearly structured preliminary drawing in pen and ink of Sylvius, dating from *c.* 1646, and the related etching. Rembrandt has subtly captured Sylvius leaning forward as if out of a pulpit, persuading his congregation of a point. The lighting in the etching is especially brilliant, falling from the uncharacteristic right-hand side (due to the inversion of the composition in the printing process) and casting a shadow under the preacher's hand, giving emphasis to Sylvius's forceful gesture. The inscription in the print, missing but anticipated in the drawings, was written by Caspar Barlaeus and testifies to Sylvius's powers as an orator.

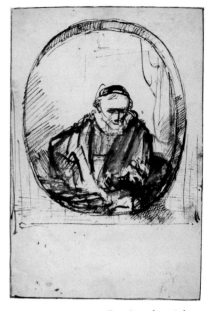

Jan Cornelisz. Sylvius
c. 1646. Pen and brown ink, touched with white, 28.5 x 19.5 cm

Jan Cornelisz. Sylvius, preacher
1646. Etching, drypoint, burin and surface tone, 27.8 x 18.8 cm

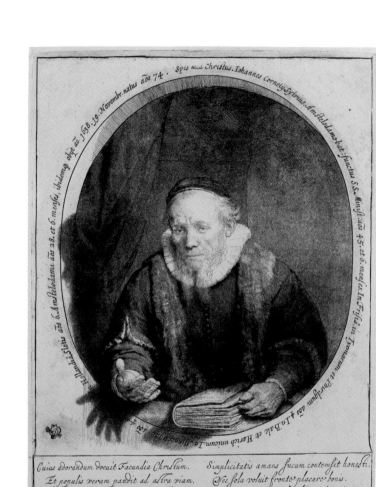

Spes mea Christus. Iohannes Cornelij Sylvius Amstelodamus obijt Iunctus S.S. Ministr. añs 45. et 6. mens. (a.) In Frisiâ in Tremenum et Phrisiûm añs 4.) L. Bolx. et Harlich et Harich unicum, Leûminæ, Franiks. añs 74. natus añs 1558. 19. Novembr. Hollandi. Slotû añs 28. et 6. mens. [illegible] Amstelodami añs 6.

Cuius adorandum docuit Facundia Christum, Simplicitatis amans, fucum contemsit honesti,
 Et populis veram pandit ad astra viam. Nec sola voluit fronte placere bonis.
Talis erat Sylvî facies, audivimus illum Sic statuit: Iesum vita meliore doceri
 Amstelys illo civibus oro loqui. Rectius, et vocum fulmina posse minus.
Hoc Frisiis præcepta dedit; pietasq́. severo Amstela, sis memor extincti, qui condidit urbem
 Relligioq́. diu vindice tuta stetit. Moribus, hanc ipso fulsit ille Deo.
Præluxit, veneranda suis virtutibus, ætas C. Barlæus.
 Erudytq́. ipsos sessa senecta viros. Haud ampliùs deprædico illius dotes,
 Quas æmulor, frustrâque persequor versu.
 P. S.

33

THE COMPOSITION of the print of Jan Cornelisz. Sylvius (p. 33) was an end product in itself and seems not to have been intended to become an oil portrait, unlike Rembrandt's gloriously rendered image of the minister and preacher Cornelis Claesz. Anslo, of whom there is a chalk drawing (opposite) and a fine etching (p. 36) in the British Museum, a related pen-and-ink drawing in the Louvre, and a dazzling oil portrait of him with his wife (Berlin, p. 37). Anslo was a famous orator and leader of the Mennonite sect, which met in a converted warehouse in Amsterdam, not far from Rembrandt's home. In 1644 Anslo's renowned voice was extolled by the leading Dutch poet, Joost van den Vondel: 'O, Rembrandt, paint Cornelis's voice. The visible part is the least part of him; the invisible is known only through the ears; he who would see Anslo must hear him.'

In the drawing Rembrandt defines Anslo in red chalk, which is then heightened and corrected with white oil colour, with some red wash on pale yellowish-brown paper. The outlines of the composition are indented with a stylus for transfer to the copper plate, from which the etched portrait will be made. A stylus, almost like a scalpel but with a slightly bulbous end, indented or incised a line around forms that were to be transferred on to another surface, a method used since the Renaissance. Rembrandt's drawing *Diana at her bath* (p. 80) is similarly indented for transfer.

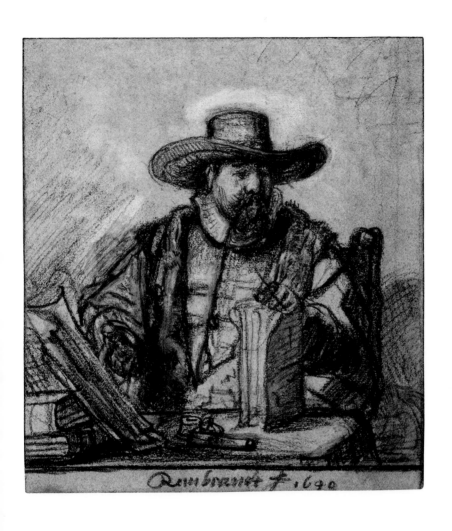

Cornelis Claesz. Anslo
1640. Red chalk with red wash, 15.7 x 14.4 cm

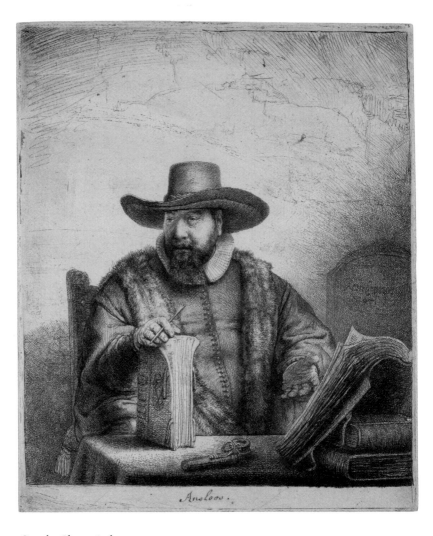

Cornelis Claesz. Anslo
1641. Etching and drypoint, 18.8 x 15.8 cm

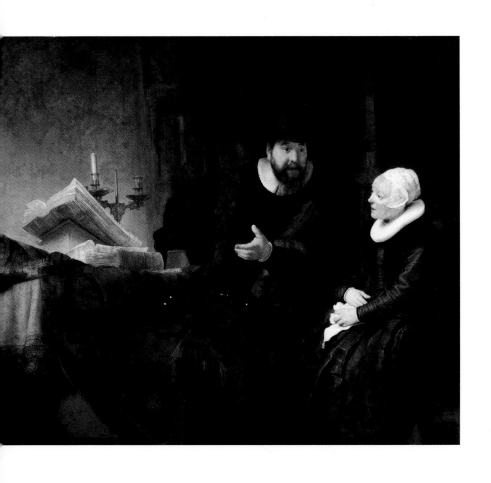

Cornelis Claesz. Anslo with his wife, Aeltje Gerritsdr. Schouten
1641. Oil on canvas, 176 x 210 cm
Gemäldegalerie, Berlin

THE JEWISH PHYSICIAN Ephraïm Bueno appears in this superb, velvety etching by Rembrandt of 1647. Bueno came from a long line of Portuguese Jewish doctors, and was a prime supporter of the Jewish printing-house run by Samuel Menasseh ben Israel, Rembrandt's opposite neighbour on the Jodenbreestraat. In the etching Bueno, wearing the distinctive hat that shows his status, pauses at the bottom of a staircase, a compositional device that Rembrandt uses in several portraits. The composition is based, very unusually, not on drawings but on a painted panel in oil (Rijksmuseum, Amsterdam), which acts as a study for this work. Images etched on to a plate are inverted when printed on to paper, and so the composition of the oil painting is the other way round to the print.

The Jewish physician Ephraïm Bueno
1647. Etching, drypoint and burin, 24.1 x 17.7 cm

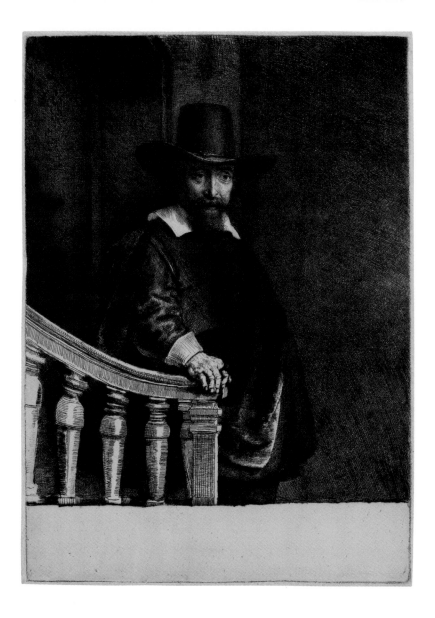

THE APOTHECARY Abraham Francen was a particularly close friend of Rembrandt and his family. He testified on Rembrandt's behalf in the 1650s and 1660s; he helped Titus and acted as guardian to Cornelia, the daughter of Rembrandt and Hendrickje. A keen collector of art, this portrait of *c.* 1657 in etching and drypoint shows Francen among eclectic objects: a triptych, a landscape painting, a skull, jars and a sculpture of an oriental Taoist deity. The print is on Japanese paper, which Rembrandt used often, particularly for prints that he considered special. The paper offers greater absorbency and, although wonderfully fine, is more difficult to tear because of the long fibres for which it is renowned. It also gives a particularly soft finish to the etched lines. Perhaps Rembrandt thought the material appropriate for a portrait of a collector of oriental art.

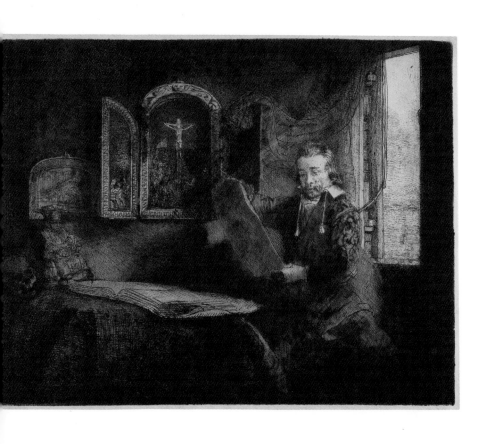

Abraham Francen, apothecary
c. 1657. Etching, drypoint and burin, 15.8 x 20.8 cm

ARNOUT THOLINX was a physician of great renown and influence, and firmly part of the Amsterdam Establishment. As well as running his own flourishing medical practice, he had also been the inspector of the Amsterdam Collegium Medicum (the Company of Physicians). He commissioned portraits of himself – one etched and one in oil – from Rembrandt when the artist experienced financial difficulties in the mid-1650s.

Tholinx was part of a close-knit circle of Rembrandt's patrons: he was married to Catharina, eldest daughter of Dr Nicolaes Tulp, the subject of one of Rembrandt's most famous paintings, *The anatomy lesson of Dr Nicolaes Tulp.* Catharina's sister, Margaretha, married Rembrandt's close friend Jan Six in 1654 (see p. 45). There is a close similarity between this portrait etching of Tholinx and Rembrandt's painted portrait of Jan Six of the same period, now in the Six Collection, Amsterdam.

Arnout Tholinx
c. 1656. Etching, drypoint and burin, 19.8 x 14.9 cm

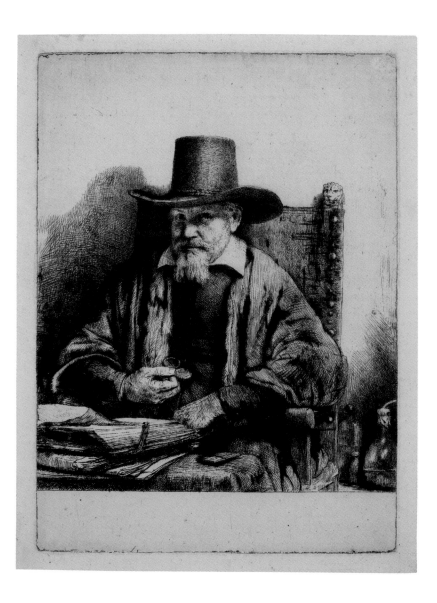

This printed portrait of Rembrandt's friend Jan Six leaning against an open window was created in stupendous quality in etching and drypoint in 1647. Six, a rich merchant and man of letters, who inherited great wealth from his mother, is shown here aged twenty-nine. The plate is densely worked with etched lines while the light hair-like lines of Six's coiffure are in drypoint. The paper is allowed to shine through, unadulterated, to suggest the blaze of light through the window. The room is likely to have been in Six's then home at 103 Kloveniersburgwal, Amsterdam.

Jan Six
1647. Etching, drypoint and burin, 24.4 x 19.1 cm

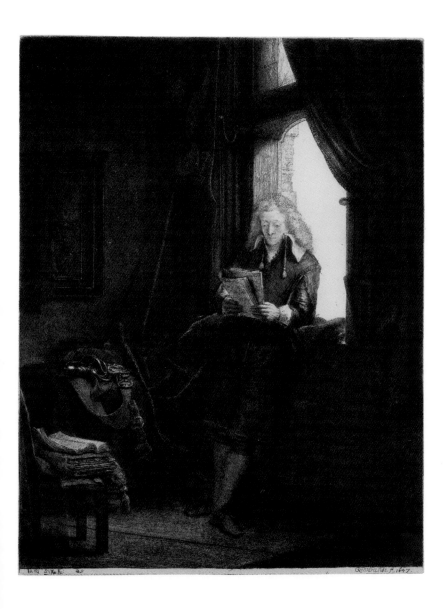

THIS SKETCH depicts Maria Trip, the daughter of Elias Trip. The Trips were an immensely affluent and influential family in Amsterdam, being arms dealers in a period of conflict. To reflect their status they built an impressive stately house, the Trippenhuis, quite close to the Rembrandthuis. They were frequent patrons of the local great master, and family members across the generations were portrayed by Rembrandt, including Maria's mother (Aletta Adriaens), uncle (Jacob Trip) and aunt (Margareta de Geer).

This drawing relates to Rembrandt's elegant oil portrait of Maria, painted in 1639 and currently on loan to the Rijksmuseum, Amsterdam. In both she is shown wearing a fashionable flat lace collar and holding a fan in her left hand. The drawing is much darker now than it would originally have been. This is because the artist has used iron gall ink, which was fashionable in the seventeenth century. The ink usually contains tannin (from galls from trees, particularly the oak), vitriol (iron sulphate), gum arabic (vegetable gum from the acacia tree) and water. The iron tends to rust on and into the paper, causing the image to bite through to the other side of the sheet. In this work the image has corroded not only into but through the paper.

A study for the portrait of Maria Trip
c. 1639. Pen and brown iron gall ink, with brown wash, 16 x 12.9 cm

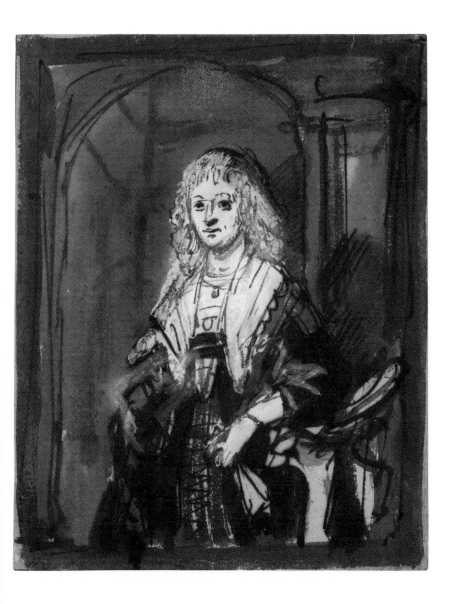

JAN LUTMA was an accomplished silversmith who made table silver for ceremonial use by the City of Amsterdam. In this sensitive portrait of old age and failing sight, Lutma is shown with the tools of his trade, along with a silver drinking vessel in the shape of a shell by his elbow, a vessel which is preserved now in the Rijksmuseum, Amsterdam.

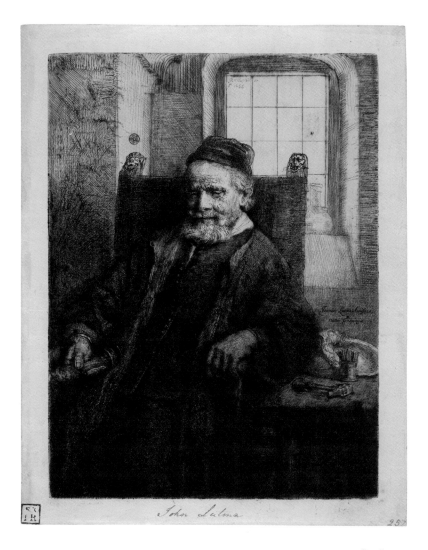

Jan Lutma
1656. Etching and drypoint, 19.6 x 15 cm

49

SCENES FROM THE BIBLE

AROUND 1632 both Rembrandt and Jan Lievens, with whom he had shared a studio, appear to have been working through ideas of how to depict the miraculous moment of the Raising of Lazarus. The exercise produced at least five drawings, one large etching and an oil painting (now in the Los Angeles County Museum of Art), all by Rembrandt, along with one print and an oil (now in the Royal Pavilion Art Gallery, Brighton) by Lievens. Both artists charge the subject with high drama.

In the work opposite, Rembrandt draws in red chalk two themes, the Entombment of Christ and the Raising of Lazarus, on a single sheet of paper. Compositionally they intermingle, even though the subjects are quite different. It seems that Rembrandt was probably working on the drawing while studying Lievens's etching of the Raising of Lazarus as well as an engraving of the same subject by Jacob Louijs. The style is consistent with other drawings of the mid-1630s. Among a cascade of figures descending into the lower left, a slumped body is carried towards a tomb. In the tomb, another body is starting to sit up with its arms raised. Behind and above stand tall figures in a splash of light.

Through a complicated process of development, the remarkably large etching by Rembrandt (p. 52) captures a visually rationalized moment of high Baroque drama. The tall figure of Christ in the foreground, dark against the dazzling light, has raised his hand to command Lazarus back from death to life. As Lazarus 'awakens', as if from deep slumber, the witnesses fling their arms out in understandable disbelief. The composition anticipates Rembrandt's representation of the Entombment (p. 53).

The Entombment of Christ, over the Raising of Lazarus
c. 1635. Red chalk, corrected with white, 28.2 x 20.4 cm

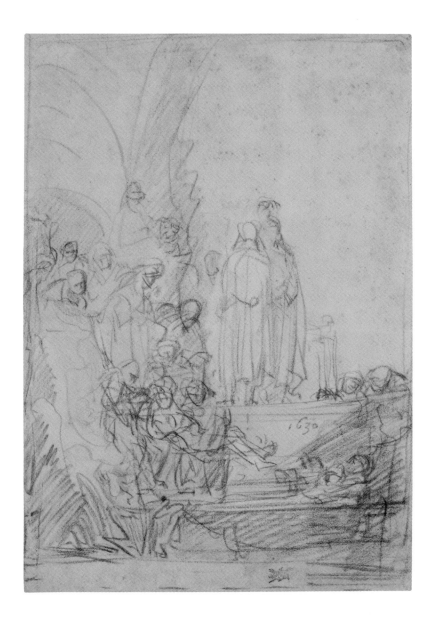

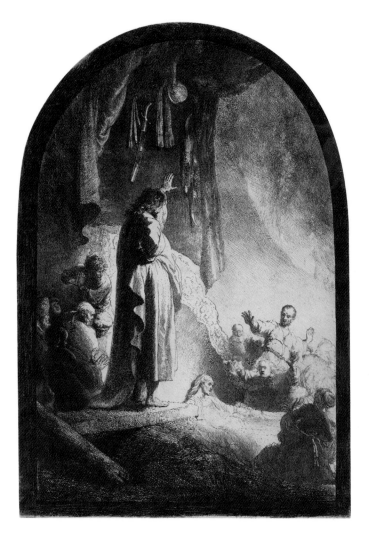

The raising of Lazarus (larger plate)
c. 1632. Etching and burin, touched with graphite, 36.6 x 25.8 cm

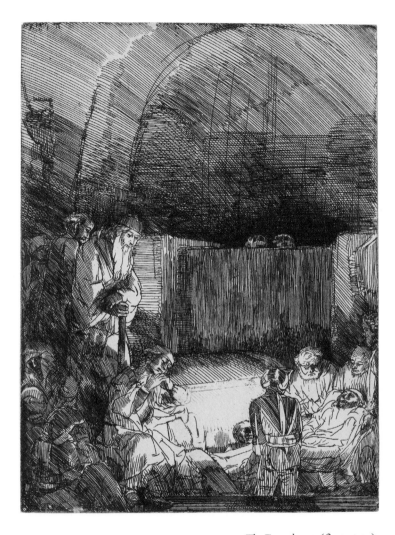

The Entombment (first state)
c. 1654. Etching, drypoint and burin, 21.1 x 16.1 cm

This drawing was made as a study for two oil paintings, now in St Petersburg and Munich. In the design, Rembrandt gives the impression of thinking aloud on paper to develop the composition. To test his faith, Abraham is told to prepare his precious son Isaac for sacrifice to the Lord. At the moment when the bearded Abraham is about to wield a knife to cut the throat of his son, an angel swoops down and wrests his hand, causing the knife to fall from his grip.

Rembrandt returned to the subject in a later etching of 1655. His sympathy with the human predicament in such testing circumstances, and his skilful way of communicating it, becomes his strength throughout his career.

The angel preventing Abraham from sacrificing his son, Isaac
c. 1634–5. Red and black chalk with grey wash, 19.5 x 14.7 cm

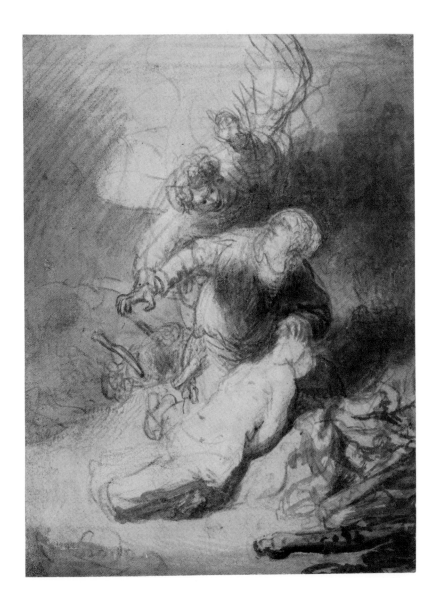

REMBRANDT MADE two separate plates of *The descent from the Cross* in 1633; this is the second and clearer version. They are both related to the oil painting of the same subject, now in Munich, which Rembrandt was commissioned to paint for Frederik Hendrik, Prince of Orange, in 1632–3.

The drama of the moment is created by the strident shaft of dazzling light which highlights the straining effort of those helping to lower the body of the dead Christ from the Cross in a linen sheet, which catches the light and articulates Christ's human form. The figure on the ladder, awkwardly determined to hold the weight of Christ's body by the arm, looks surprisingly like Rembrandt himself. The Temple of Jerusalem is visible in the distance.

The third state of this print was published by Hendrik van Uylenburgh while the fourth was published by Justus Danckers. This switch of publishers is rather unusual in Rembrandt's printed work but it may show that this print, reproducing an oil painting, was intended for a wider public market than many of Rembrandt's more intimate prints.

The descent from the Cross (second plate)
1633. Etching and burin, 53 x 41 cm

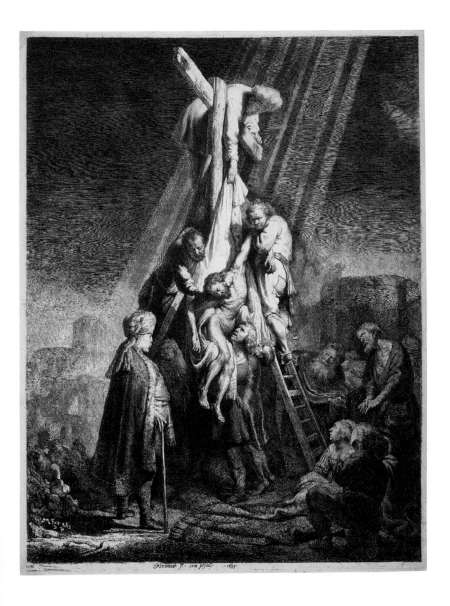

57

REMBRANDT was one of many artists influenced by the great German Renaissance printmaker Albrecht Dürer (1475–1528), and several of his compositions echo those of the German master, including the etching and drypoint *The death of the Virgin* of 1639. The angel appears at top right to announce to Mary that her death is imminent. The compositional format owes much to Dürer's woodcut of the same title – of which Rembrandt owned an impression – from the major series *The life of the Virgin*, which had been widely known throughout Europe since the early sixteenth century.

The work of Dürer also informs Rembrandt's etching *Adam and Eve* (p. 60), made in 1638, the year in which he bought a group of Dürer prints. Closely connected with Dürer's *Engraved Passion*, this Rembrandt print offers an unabashed view of the naked Adam and Eve, silhouetted against a blaze of light, around the edge of which is a dragon-like beast or serpent, redolent of one in Dürer's engraving of *Christ in Limbo* (p. 61).

The death of the Virgin
1639. Etching and drypoint, 40.9 x 31.5 cm

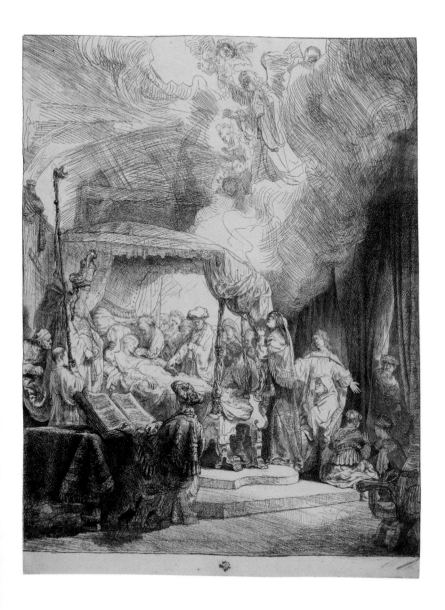

59

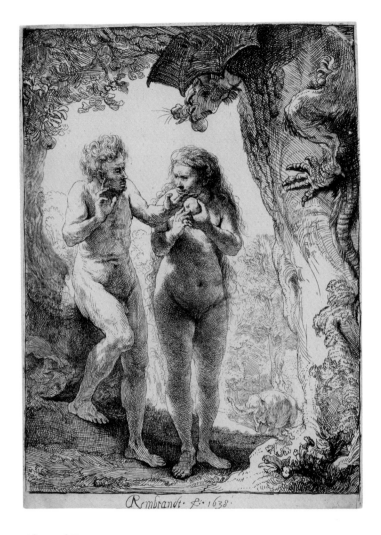

Adam and Eve
1638. Etching, 16.2 x 11.6 cm

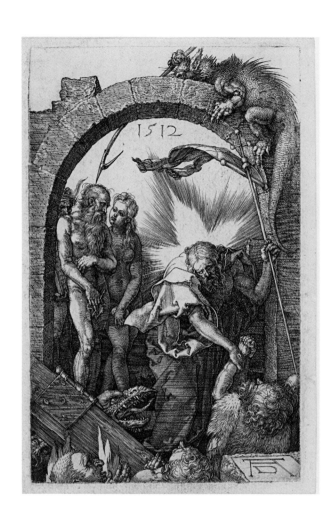

Christ in Limbo, from the *Engraved Passion* by Albrecht Dürer
1512. Engraving, 11.8 x 7.5 cm

THIS PRINT of *Christ healing the sick* is also known as the *Hundred guilder print* because, although it was thought to be worth about thirty guilders, its rare beauty attracted a higher price and, supposedly, Rembrandt himself had to pay 100 guilders to buy back a particular impression of it. It is one of two prints with biblical subjects that are especially celebrated in Rembrandt's output, the other being *The three crosses* of 1653 (pp. 66–7).

Although the *Hundred guilder print*, in etching and drypoint, represents several episodes, the central theme is Christ as a healer, especially of children, echoing Matthew 19, 13–14: 'Then there were brought unto him little children, that he should put his hands on them, and pray. And the disciples rebuked them: but Jesus said: Suffer little children, and forbid them not to come unto me: for such is the kingdom of heaven.' Babies in their mothers' arms are brought to Christ, while sick adults, brought in a wheelbarrow and on stretchers, await their turn. Meanwhile, the Pharisees, at centre left, rather incongruously argue with Christ on the legality of divorce.

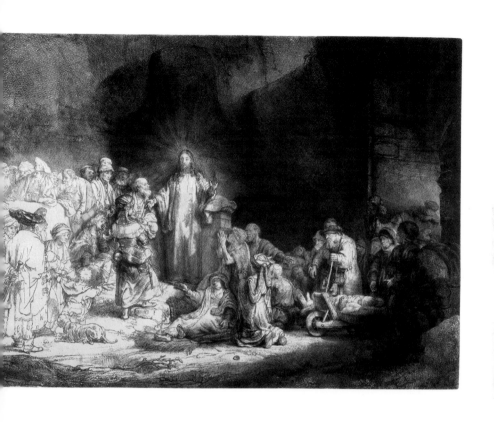

Christ healing the sick: the hundred guilder print
c. 1648. Etching with drypoint and burin, 27.8 x 38.8 cm

ONE OF THE most physically complex of Rembrandt's drawings is *The Lamentation at the foot of the Cross* of *c.* 1634–5. It comprises brown ink, brown wash and red and black chalks, reworked in oils: the lines framing the drawing are in black oil paint. This combination of an oil-based pigment and chalks is difficult should repairs be needed. The surface of the drawing is uneven as the sheet includes cut sections of paper, making a type of collage, as Rembrandt has changed his mind about various sections of the composition. It is a compositional drawing apparently working towards the full oil sketch in the National Gallery, London.

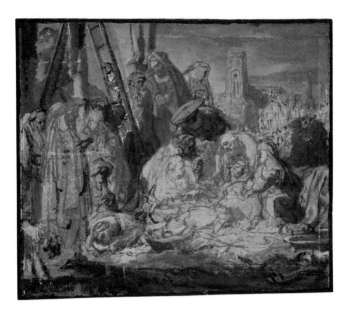

The Lamentation at the foot of the Cross
c. 1634–5. Pen and brown ink and brown wash, with red and perhaps some black chalk, 21.6 x 25.4 cm

THE MAJESTIC *Three crosses* of 1653 is a print of astonishing scale, aspiration and technique. Made with a drypoint and burin, it is a plate on which Rembrandt worked extensively, creating a total of four states. It offers the most famous example of an etched composition being changed, the most striking alteration happening between the third and fourth states (pp. 66–7).

The subject represents the actual moment of Christ's death on the Cross, a scene of the highest drama and significance. It is interesting to see how Rembrandt interprets his source, probably the Gospel of St Luke (23: 44–8): 'By now it was about midday and a darkness fell over the whole land, which lasted until three in the afternoon: the sun light failed . . . Then Jesus gave a loud cry and said, "Father into thy hands I commit my spirit"; and with these words, he died. The centurion saw it all and gave praise to God. "Beyond all doubt", he said, "this man was innocent".'

In the early states, I–III, Rembrandt evokes the darkness falling on the earth, but reserves a dramatic spotlight for the moment when Christ lifts up his head. St Luke's is the only gospel to mention this and Rembrandt shows the bearded Christ wearing the crown of thorns and slightly raising his head to speak. The centurion kneels, hands outstretched in recognition of the importance of what he is witnessing, while the Virgin Mary, other women and attendants on the right are overcome with grief, the poignancy of which is brilliantly communicated: the Virgin has lost her son.

Technically, drypoint lines are vulnerable to being flattened after pressure has been exerted on them to make a print. Therefore, this plate, entirely in drypoint, needed reworking in part if more prints were to be taken from it. It seems that Rembrandt made the changes to the plate but that it was printed by a professional printer, to whom he writes an instruction on the back of one of the impressions. Between the third and fourth states Rembrandt reworked the area of the horseman at the foot of the Cross: in state III he is dismounted, kneeling towards the Cross while the horse faces left; in state IV he is mounted and the horse faces right. This reworking would have strengthened a part of the composition and plate to extend the possibility of printing off more impressions.

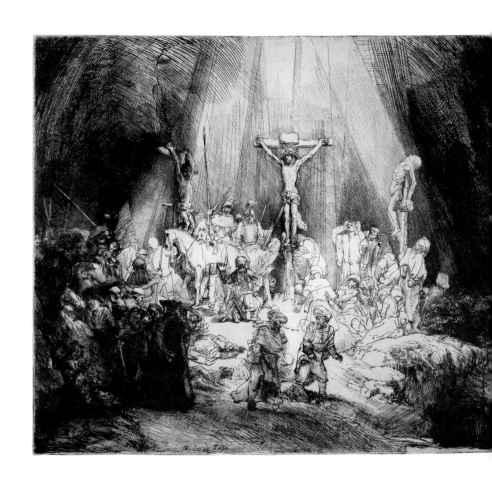

The three crosses (third state)
1653. Drypoint and burin, 38.5 x 45 cm

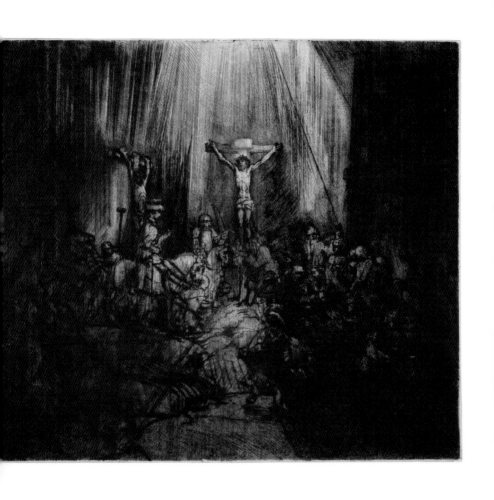

The three crosses (fourth state)
1653. Drypoint and burin, 38.5 x 45 cm

LANDSCAPE

As religious strictures were loosened in the Protestant North, the preoccupation with art representing religious subjects shifted to allow more development of other subjects and themes. In the late sixteenth and throughout the seventeenth century, we find landscape rapidly developing into a subject in its own right in Northern painting, drawing and printmaking, rather than acting as a backdrop to religious, mythological or historical subjects. The Dutch in particular display great pride in illustrating their homeland, perhaps, it has been suggested, due to their long military campaign to assure their independence from the threat of Spanish Catholic control. They similarly gloried in depicting their towns and cities, showing a gentle pride in their civic accomplishment, against the odds in a land where so much of the territory was, and is, below sea level.

There is a dazzling economy of detail in this drawing. With no marks adulterating the sky or crop in the foreground field, the paper is allowed to shine through as if there is a highlight glancing off the surface of the field or a blaze of light across the bright sky. Working in pen and brown ink for the crisper, structural lines, Rembrandt uses brown wash extremely sensitively to build up a sense of the depth of the crop in the field by picking out a path through it, on the left of the drawing.

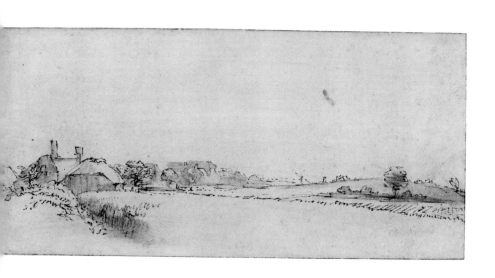

Landscape with cottages, meadows and a distant windmill
c. 1650. Pen and brown ink with brown wash, 9.8 x 21.2 cm

THIS IS A MASTERPIECE of landscape drawing, evoking atmosphere, light, shade and breeze with consummate skill. The scene depicted is the house and estate of Kostverloren, a well-known site a few miles south of Amsterdam, which was a regular haunt of artists. Rembrandt portrayed it six times — other examples are in Dresden and Chicago — and it was also represented by Hobbema and Jacob van Ruisdael. On the river Amstel, Kostverloren was an expensive estate to manage: its name literally means 'money wasted' because of the funds expended and lost on its maintenance.

The drawing evokes strong sunlight in a masterly way, casting heavy shadows that distinguish areas of the landscape and composition. The structure is demarcated with a reed pen, in brown ink, while the shadows are marvellously applied with a soft brush and wash.

An added point of interest in this drawing is the 'F' in the lower right-hand corner. This proves that the work was once owned by N.A. Flinck, the son of one of Rembrandt's foremost pupils, Govert Flinck. Flinck, who was commissioned to paint the prestigious decorations for the Amsterdam Town Hall, was with Rembrandt between around 1633 and 1636. His collection of Rembrandt circle drawings passed to his son and was bought in Rotterdam in the eighteenth century by the 3rd Duke of Devonshire. Subsequently at Chatsworth in Derbyshire, the drawing came to the British Museum in 1984.

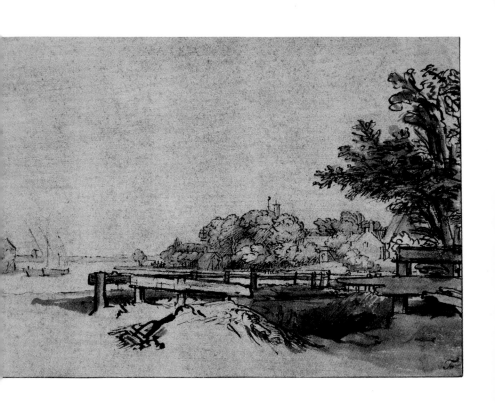

Landscape: the bend in the Amstel at Kostverloren House, with a dug-out in the foreground
c. 1650. Pen and brown ink with brown wash, 14.5 x 21.3 cm

THIS FAMOUS ETCHING and drypoint has a wonderfully sketchy quality for a print that has been inscribed into a copper plate. It has the sense of having been sketched directly and quickly into the plate in the open air, in front of the subject. The speed and immediacy is conveyed through the looped strokes of the foliage in the trees on the left and the grass on the right. A story first recounted by Gersaint, in the mid-seventeenth century, tells how Jan Six bet Rembrandt that the artist could not make the print in the time it took someone to fetch a pot of mustard from the local village.

Despite the expansive sky, which results from the very low viewpoint, the print is, in fact, barely the size of a postcard. In the eighteenth century it was thought that this etching was made by Rembrandt when he was with Jan Six on the latter's estate. Since then Ouderkerk has been identified behind the trees on the left, thereby placing this view on the west bank of the river Amstel, on the Klein-Kostverloren estate, then owned by Albert Coenraedz. Burgh, who later became burgomaster of Amsterdam.

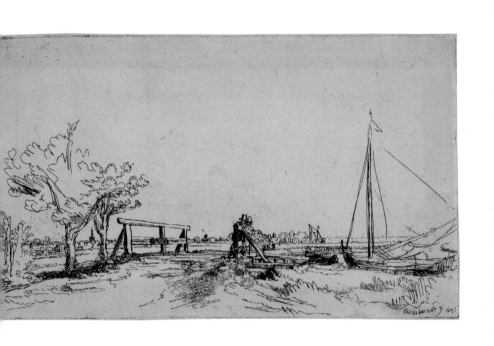

Six's Bridge
1645. Etching, 12.9 x 22.4 cm

REMBRANDT's masterpiece of etched landscape is *The three trees* of 1643, produced within a year of his dramatic painting *The Night Watch* (see p. 9). Although the subjects of the two works are very different, they share a grandiose theatricality, high drama and a powerful interplay of dazzling light and dark shadows. Compared with the etching *Six's Bridge* (p. 73), so light and speedy in its execution, *The three trees* has had much effort lavished on it, using the various techniques of etching, drypoint and burin. This is a set-piece composition. Beyond the majestic, billowing clouds, so typical of the classical phase of Dutch landscape in the mid- to late seventeenth century, poking above the horizon is the silhouette of a city; in the middle distance, bathed in sunlight, are open pastures with grazing cattle. Against the burst of light on the right are three tall mature trees, which stand like the three crosses on Calvary. On the leafy bank below them is dense vegetation, and barely perceptible within the bank is a roundel in which we may just see a courting couple. On the river bank nearby, an older couple wait patiently for a fish to take the bait from the man's fishing rod. The drama of this otherwise peaceful scene is enhanced by the shafts of light and shade incised into the copper plate with a ruler across the top left corner. Perhaps Rembrandt is making the point that he can inject the drama found in one of his religious compositions, such as the crucifixion of Christ and the two thieves on Calvary (pp. 66–7), into a work that is purely a landscape.

Within the shafts of light descending from the centre-left is a collector's mark comprising a palette containing a 'D'. This shows that the print was once held by the scurrilous Robert Dighton, an artist, 'collector' and thief, who often applied his mark most insensitively to fine prints by Dürer and Rembrandt.

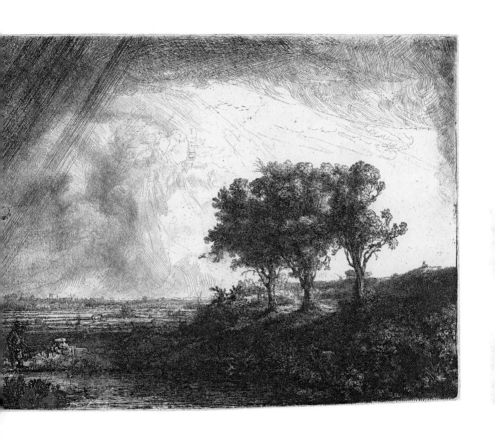

As REMBRANDT was the son of a miller, this etching of a windmill is perhaps the most pertinent of his landscapes. Rembrandt's eye for detail in the type of building he must have known well since childhood shows through clearly. The windmill is identifiable as the Little Stink Mill on De Passeerde bulwark, or 'wall of earth', which ran along the west side of Amsterdam. This and the Large Stink Mill were owned by the Leathermakers' Guild, which used them to soften tanned leather using smelly cod liver oil, hence the addition of 'Stink' to their names. The very light and sketchy way in which the etching needle has been drawn over and into the surface of the copper plate strongly suggests that the composition was made in the open air, in front of the subject. The positioning of the subject has been inverted in the printmaking process, although the artist has written his name in reverse on the plate so that it reads correctly.

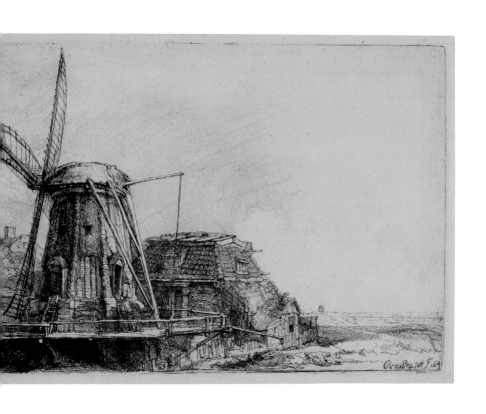

The windmill
1641. Etching, 14.5 x 20.8 cm

REMBRANDT was the master of economy of detail. This drawing of a broad open landscape is typical of the master's style, emulated by several of his pupils. The paper is allowed to shine through in wide expanses, hinting at the light falling across sweeping areas of the landscape. In the foreground to the left, the artist has used, appropriately, the reed pen to discern the rushes and reeds which mark the line of the water's edge. In the middle distance, the enclave of trees and buildings, with a tower acting as the focal point, is drawn with different tones of soft wash in brown ink, with the shapes of the clearer buildings being drawn with a finer reed pen. The artist imbues the scene with a wonderful sense of a bright atmosphere.

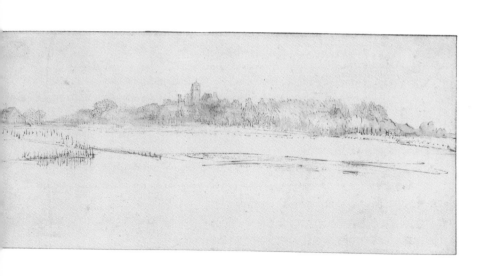

Landscape with the house with the little tower
Early 1650s. Pen and brown ink and brown wash, 9.7 x 21.4 cm
J. Paul Getty Museum, Los Angeles

OTHER WORKS

COMPARED with biblical subjects, landscape and portraiture, Rembrandt rarely illustrates mythological or historical subjects. This drawing of a nude, *Diana at the bath*, dates from early in his career, around 1630–31. The subject looks very like his wife, Saskia, and we have to search hard for a symbol to suggest that this is Diana, goddess of the hunt. However, in the related etching, the hunting equipment of a quiver full of arrows, by the model's left hand, clarifies the subject, even though there is no hint of a crescent moon in her hair, the goddess's other symbol.

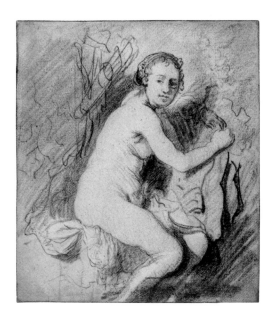

Diana at the bath
c. 1630–31. Black chalk with brown wash, 18.1 x 16.4 cm

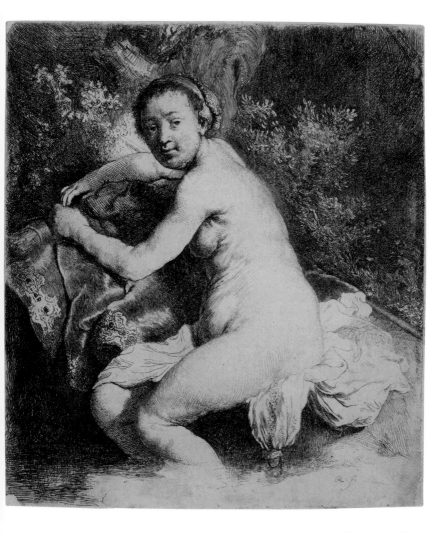

Diana at the bath
c. 1631. Etching, 17.8 x 15.9 cm

81

IN 1631 AND 1659, Rembrandt investigates the theme of Jupiter and Antiope. The achievement of the later, large plate is extraordinarily skilled in composition and execution. Rembrandt places the subject of Jupiter, disguised as a satyr, approaching the languorous, sleeping nude, Antiope, so close to the front of the picture that we feel that we are in the same bed. The masterly manipulation of light, glancing off Antiope, heightens the somewhat charged atmosphere which will culminate in Jupiter ravishing the Greek nymph. This would have been based on Ovid's *Metamorphoses* (Book 6: 110–111), which was very popular at the time. Also a favourite with Bernini and Rubens, the volume was Rembrandt's most frequently used source for mythological compositions.

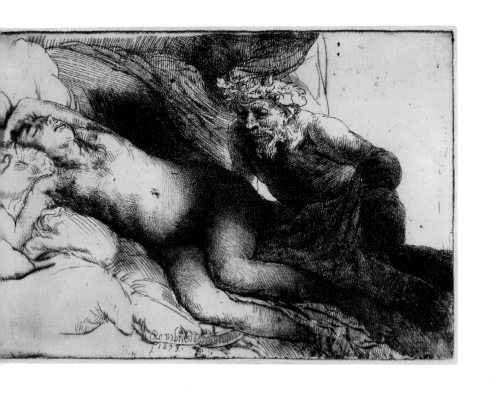

Jupiter and Antiope (large plate)
1659. Etching, drypoint and burin, 13.8 x 20.5 cm

THIS WONDERFULLY observed image of a rat-catcher — and of the human reaction to such a pedlar touting for business — was etched by Rembrandt in his early years as a master in Amsterdam. Through the image Rembrandt evokes smell: the householder cannot bear to face the visiting pedlar, presumably because of the stench of the dead, poisoned, rotting rats strung up around the wicker cage held aloft on the pole. It is not quite a caricature, but the way in which the bearded head of the rat-catcher is observed is similar to the character heads that were popular in Dutch art at this period. The boy accompanying him has a bandaged head: perhaps he is suffering from treatment given by the rat-catcher acting as a dentist.

The rat-catcher
1632. Etching and burin, 14 x 12.5 cm

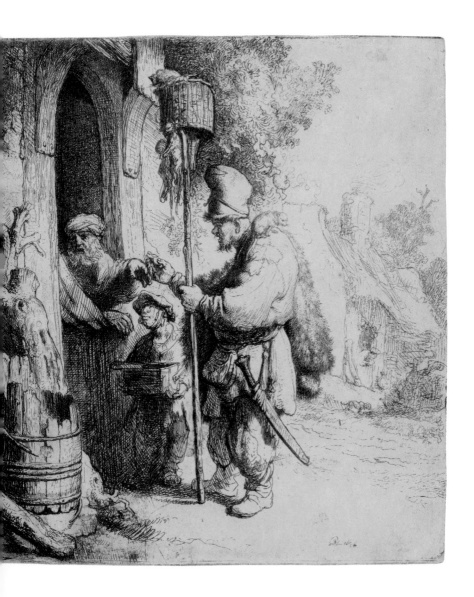

Rembrandt's use of black chalk, which draws as grey, is used to remarkable effect in his *Elephant* of *c.* 1637. Here, the darker areas of shadow are drawn with charcoal. This drawing shows the difference in surface of the two media: chalk has a slight glint to its surface whereas charcoal is matt and its black is denser. This elephant is likely to be Hansken – a female despite her name – who visited Amsterdam in the mid-1630s.

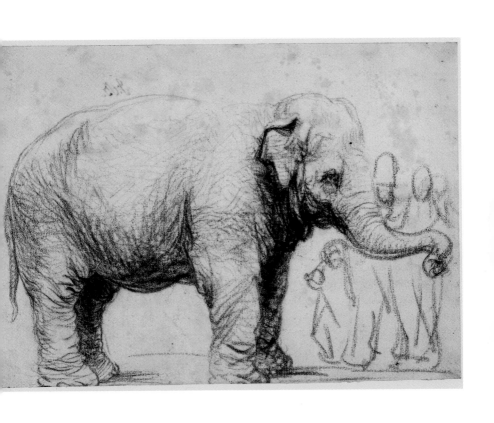

An elephant
c. 1637. Black chalk and charcoal, 17.9 x 25.6 cm

THIS ETCHING of 1643 allows an insight into a regular scene in Dutch villages and towns. It was usual for homes to fatten up a pig during the summer months and to slaughter it for winter meat as the season changed. The way in which this creature is tied up by the trotters shows that she awaits this fate. She is brilliantly observed and rendered in great detail by Rembrandt using the etching needle to sketch deeper lines to delineate the sow and lighter, shallower lines to hint at the recession of the surroundings. The man in the doorway, barely visible, holds a bag with his instruments, including an axe and a curved yoke, or cambrel, from which an animal's carcass will be hung. Fortunately, unlike most artists who represented this scene, Rembrandt chooses the moment before the grisly action takes place, observing the quirky anatomy of the creature, while the children anticipate the ghastly spectacle to come.

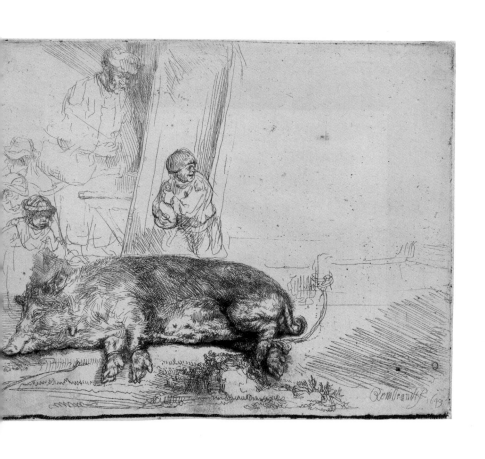

The sow
1643. Etching and drypoint, 14.5 x 18.4 cm

Rembrandt occasionally represented the religious customs of his own culture. This pen and ink drawing, *The Star of the Kings*, illustrates the way in which the Dutch celebrated the Epiphany on 6 January. Commemorating the manifestation of Christ to the wise men or Magi from the east, children would visit houses asking for alms, and then treats, while holding a lantern in the form of the 'Star of the Kings'.

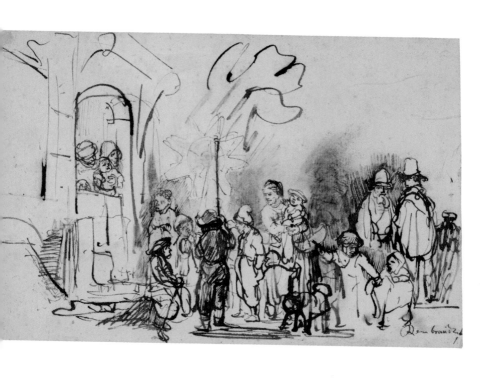

The Star of the Kings
c. 1645–7. Pen and brown ink with brown wash, 20.4 x 32.3 cm

CHRONOLOGY

1606 Rembrandt van Rijn is born in Leiden

1620 Enrols at Leiden University

1621 Apprenticed to Jacob van Swanenburgh in Leiden

1624–5 Pupil of Pieter Lastman in Amsterdam

1625 Becomes an independent painter in Leiden

1631 Back in Amsterdam, where he is to settle permanently

1632 Paints *The anatomy lesson of Dr Tulp*

1633 Betrothed to Saskia van Uylenburgh

1633–9 Makes a series of six paintings of Christ's Passion for Prince Frederik Hendrik of Orange

1634 Marries Saskia

1639 Buys the large house on the Jodenbreestraat, Amsterdam (now the Rembrandthuis Museum)

1641 Draws, etches and paints the portrait of *Cornelis Anslo and his wife*

1641 Rembrandt and Saskia's son Titus is born, their only child to survive into adulthood

1642 Saskia dies. Rembrandt completes the huge group portrait *The Military Company of Captain Frans Banning Cocq*, the so-called *Night Watch*

By 1649 Hendrickje Stoffels enters Rembrandt's house, replacing Geertge Dircx

1653 Designs the great etching *The three crosses*

1654 Cornelia, the daughter of Rembrandt and Hendrickje, is born

1656 Rembrandt is declared insolvent and sells his assets, house and collection to pay his debts

1661 Paints *The conspiracy of Claudius Civilis* for the Town Hall, Amsterdam

1668 Rembrandt's son Titus dies

1669 Rembrandt dies in Amsterdam and is buried in the Westerkerk

FURTHER READING

The literature on Rembrandt is vast. The following list is intended as a guide to recommended books with an emphasis on those written or available in English and which relate closely to the collection of the British Museum. Each volume cited contains an excellent bibliography to guide more specialized reading.

Kenneth Clark, *Rembrandt and the Italian Renaissance*, London, 1966
Kenneth Clark, *An Introduction to Rembrandt*, London, 1978
Egbert Haverkamp-Begemann, *Rembrandt: the Nightwatch*, Princeton, 1982
Erik Hinterding, Ger Luijten and Martin Royalton-Kisch, *Rembrandt the Printmaker*, London and Amsterdam, 2000
Martin Royalton-Kisch, *Drawings by Rembrandt and his Circle in the British Museum*, London, 1992. An outstanding and comprehensive work, which is the most up to date on its subject.
Christopher White, *Rembrandt*, London, 1984

The following catalogues specifically relate to how Rembrandt's works are kept in the British Museum and are also interesting documents of connoisseurship:

A.M. Hind, *Rembrandt and his School*, London, 1915 (for the drawings)
A.M. Hind, *A Catalogue of Rembrandt's Etchings*, 2 vols, London, 1912 (2nd ed. 1924)

HISTORICAL CONTEXT

Anthony Bailey, *Rembrandt's House*, London, 1978
Simon Schama, *The Embarrassment of Riches: an Interpretation of Dutch Culture in the Golden Age*, London, 1987 and 1991

TECHNICAL GLOSSARY

BURIN: A sharp, metal instrument, usually 'V'- or lozenge shaped at its end, for incising lines into a metal printing plate.

DRYPOINT: A process of scratching into the naked surface of a metal plate used for printing, using a drypoint needle, a fine, sharp, usually steel-tipped instrument. Unlike etching (see below), acid is not used to deepen the lines, so it is a dry process.

ETCHING: Derives its name from the German word *ätzung*, meaning 'to bite'. A metal plate, usually of copper, is coated with a ground made of wax or bitumen, to make the so-called acid-resist ground. A design is then scratched through this ground, using an etching needle. The plate is then dipped into an acid bath: the acid bites at the lines which have been exposed through the ground. The plate is drained, dried and dabbed with ink, which goes into the lines. The plate is then cleaned so that ink is retained only in the lines or grooves. Moist paper is placed on top and the plate plus paper is passed through the pressure of the printing press.

GRAPHITE: A naturally occurring metallic substance. When used to draw on paper, its grey–black mark has a sheen and catches the light, unlike charcoal, which looks matt. Its appearance is harder than that of black chalk, which is soft in effect.

IMPRESSION: Every time a print is made from a plate, this is an impression.

IRON GALL INK: A form of ink in vogue especially during the seventeenth century throughout Europe. Rembrandt, Claude Lorrain and Guercino are particularly known for their expert use of it. It was made using the amber resin secreted in galls, little balls forming from acorns when insects burrow into them. This is ground up and mixed with a flux and water. Often iron gall ink has a high ferrous content and, with oxidization over the years, effectively becomes rusty and corroded, biting through the paper. For more information, see http://www.knaw.nl/ecpa/ink/ink.html.

JAPANESE PAPER: Fine, flimsy paper made from long fibres: often good for accentuating delicate details.

PLATE: The metal plate on and into which a design is incised: in Rembrandt's case, almost always made of copper. Zinc or steel are the most common alternatives: each metal offers distinctive visual differences to the prints taken from them.

QUILL/REED PEN: Various types of pen were available to Rembrandt. The quill, made from a bird's feather, was commonly used in Italian drawing, whereas the reed pen, made from dried reeds from river banks, is typical of Dutch drawing. The reed is cut at an angle, then with a slit to make the nib; the more the nib is used, the more ink it absorbs, and so the line becomes softer and broader.

SILVERPOINT: A traditional drawing technique using a fine silver wire (available in a choice of thicknesses), positioned in a holder. Particularly fashionable in the Renaissance, it was often used for special drawings, frequently of loved ones, due to the expense of the medium. Dürer used it occasionally, for example in his first self-portrait and in his Netherlands Sketchbook.

STATE: When a first design is on a printing plate, initially this is State I: if this design is altered with even just one line, then State II is produced. With each change, a subsequent State is produced.

VELLUM: The beaten skin from a kid goat. Vellum usually presents a shiny surface on one side and a slightly bumpy surface, complete with pore marks, on the other. Parchment is very similar but is made from the skin of a sheep.

WASH: The mixture of ink with water, which has been applied, usually in broad strokes, with a soft, sable brush.

ILLUSTRATION REFERENCES

Photographs © The Trustees of the British Museum, courtesy of the
Departments of Prints and Drawings and of Photography and Imaging

2 PD 1895,0915.1279
6 PD 1868,0822.656. Bequeathed by Felix Slade
9 © Rijksmuseum, Amsterdam
11 J. Paul Getty Museum, Los Angeles
14 PD Gg,2.248. Bequeathed by C.M. Cracherode
15 PD 1895,1214.111
16 PD 1973,U.983. Bequeathed by C.M. Cracherode
18 (top) PD 1860,0616.85
18 (bottom) PD 1860,0616.86
21 PD Gg,2.253. Bequeathed by C.M. Cracherode
22 PD 1973,U.769. Bequeathed by C.M. Cracherode
23 PD 1842,0806.134
24 PD 1973,U.737. Bequeathed by C.M. Cracherode
26 (top) PD 1910,0212.187. Bequeathed by George Salting
26 (bottom) PD 1912,0416.2
27 PD 1895,0915.1264
29 PD 1895,0915.1270
31 PD 1948,0710.7. Purchased with the aid of contributions from the Art Fund and an anonymous benefactor
32 PD 1874,0808.2272
33 PD 1973,U.984. Bequeathed by C.M. Cracherode
35 PD 1848,0911.138
36 PD 1842,0806.147
37 Gemäldegalerie, Berlin
39 PD 1847,1120.7
41 PD 1973,U.1114. Bequeathed by C.M. Cracherode
43 PD 1973,U.1109. Bequeathed by C.M. Cracherode
45 PD 1973,U.987. Bequeathed by C.M. Cracherode

47 PD 1891,0713.9
49 PD 1868,0822.696. Bequeathed by Felix Slade
51 PD T,14.6. Bequeathed by William Fawkener (?)
52 PD 1848,0911.35
53 PD 1842,0806.134
55 PD 1897,1117.5
57 PD 1973,U.934. Bequeathed by C.M. Cracherode
59 PD 1973,U.898. Bequeathed by C.M. Cracherode
60 PD 1852,1211.42
61 PD E,2.56. Bequeathed by Joseph Nollekens subject to a life interest to Francis Douce
63 PD 1973,U.1022. Bequeathed by C.M. Cracherode
64 PD Oo,9.103. Bequeathed by Richard Payne Knight
66 PD 1973,U.941. Bequeathed by C.M. Cracherode
67 PD 1848,0911.40
69 PD 1895,0915.1257
71 PD 1984,1110.9. Purchased with the aid of contributions from the National Heritage Memorial Fund and the George Bernard Shaw Fund
73 PD 1847,1120.3
75 PD 1973,U.967. Bequeathed by C.M. Cracherode
77 PD 1868,0822.687. Bequeathed by Felix Slade
79 J. Paul Getty Museum, Los Angeles
80 PD 1895,0915.1266
81 PD 1829,0415.17
83 PD 1855,0414.266
85 PD 1847,1120.5
87 PD Gg,2.259. Bequeathed by C.M. Cracherode
89 PD 1845,0205.3
91 PD 1910,0212.189. Bequeathed by George Salting